60 FORTUNE COOKIES 心諓 60 BISCUITS CHINOIS

BEIJING MEDIATIME BOOKS CO., LTD.
CN Times Books, Inc.
501 Fifth Avenue
New York, NY 10017
cntimesbooks.com

ORDERING INFORMATION
Quantity sales: Special discounts are available on quantity purchases by corporations,
associations, and others. For details, contact the publisher at the address above.
Orders by US trade bookstores and wholesalers: Please contact Ingram Publisher Services:
Tel: (866) 400-5351; Fax: (800) 838-1149; or customer.service@ingrampublisherservices.
com.

Design: Nicole Lafond

ISBN 978-162774-094-4

Printed in the United States of America

Lew Yung-Chien

劉榮黔

60 FORTUNE COOKIES 心識 60 BISCUITS CHINOIS

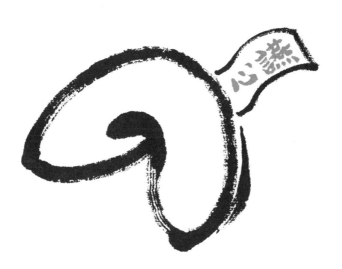

Biography

Lew Yung-Chien was born in Shanghai. After earning an arts degree at National Taiwan Normal University, he completed his studies at l'École Supérieure des Arts Modernes de Paris. Tai-chi has been a lifelong passion and he has instructed it at the university level, in hospitals and in the parks of Montreal. His book *L'esprit du taï-chi* was published in 2009. He is also a devoted calligrapher, photographer, painter, and potter. In 2014, he was elected to The Royal Canadian Academy of Arts.

Acknowledgments

This book would not have been possible without the generous collaboration of Louise Blanchard and Monique Paquin on the French text; Tina Soong and Christopher West on the English; Philip Hsieh on the Chinese; and Jean-Marc Plante on the final edit of all drafts. I am indebted to Nicole Dumais, Linda Nantel, Charles Lo, Maili Lo, Josée Malouin, Diane Milo, Kim Chi Huynh and Henrietta Jan-Han Sih for their sensitive observations on differences of interpretation among the two cultures. And a very special thank you goes to Nicole Lafond for her confidence in this project from the beginning. Lastly, I am grateful to the men, women, and children I have encountered over a lifetime, who provided the raw material for this book.

Preface

Inspired by the magic of image and an age-old philosophy, Lew Yung-Chien has lost none of the wonder of a child. He puts us in front of a work that is both reflective and joyful, one that stimulates the imagination with intentionally simple, yet universal themes.

Borrowing from two cultures, he creates a sense of harmony and balance by merging word and image, Chinese calligraphy and Western writing. The Eastern and Western idioms converge, revealing that, beyond the superficial, all humans are essentially alike.

Why 60 plates? For the Chinese, the number 60 represents a circle, a full cycle. This book gives readers of any age a symbolic chance to go over the cycle of their life. At each life stage, we humans amass experience and process it according to our personality and frame of mind at the time. From birth to adulthood, and on to old age, our perspective on the world is transformed and evolves as the circle is drawn. Lew Yung-Chien's message is that at any stage, we can revisit experience, and with renewed perspective, change the course of our lives.

Jacques Languirand, o.c., c.q.

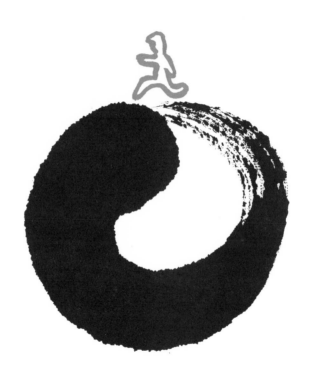

雖說人生是一個圓但不是要你總在繞圈子

THE CYCLE OF LIFE IS NO REASON TO BE GOING IN CIRCLES.

LE CYCLE DE LA VIE EST CIRCULAIRE. FAUT-IL POUR AUTANT TOUJOURS TOURNER EN ROND ?

親密的友誼
更應保持距離

THE CLOSER THE FRIENDSHIP, THE MORE WE RESPECT EACH OTHER'S SPACE.

LES AMIS INTIMES SE DOIVENT DE RESPECTER ENCORE PLUS L'ESPACE DE CHACUN.

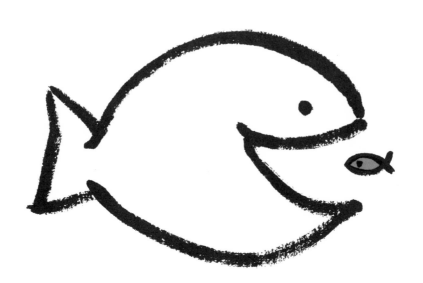

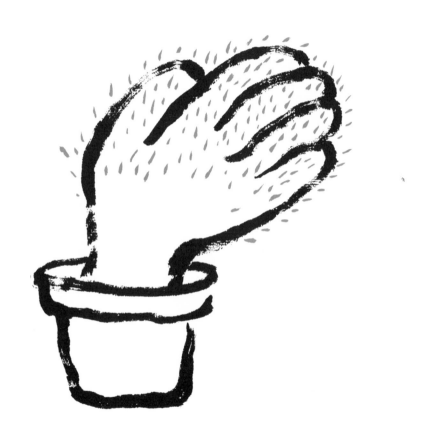

没時間澆花
那就養仙人掌吧

IF YOU DO NOT HAVE TIME TO WATER PLANTS, THEN GET A CACTUS.

SI VOUS N'AVEZ PAS LE TEMPS D'ARROSER DES PLANTES, PRENEZ SOIN D'UN CACTUS.

只要心中有太陽
不怕烏雲籠罩

A SUNNY HEART CHASES THE CLOUDS AWAY.

UN CŒUR ENSOLEILLÉ FAIT FUIR LES NUAGES.

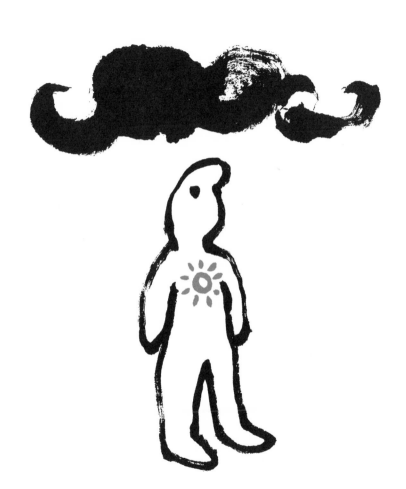

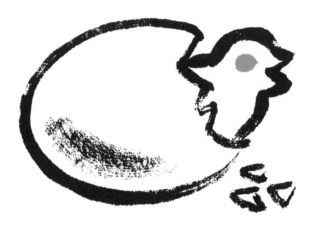

別急
到時我會自己出來

NATURAL RHYTHMS CANNOT BE RUSHED.

IL NE FAUT RIEN PRÉCIPITER : CHAQUE CHOSE EN SON TEMPS.

裁剪得太合身
很容易變得不合身

A TOO-PERFECT FIT COULD BE CONSTRICTIVE LATER ON.

LE BIEN-ÊTRE REQUIERT UNE CERTAINE LIBERTÉ DE MOUVEMENT.

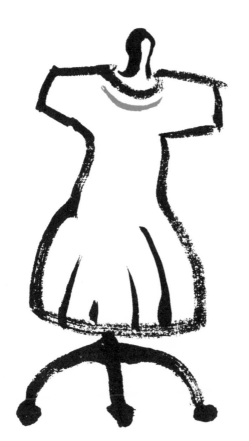

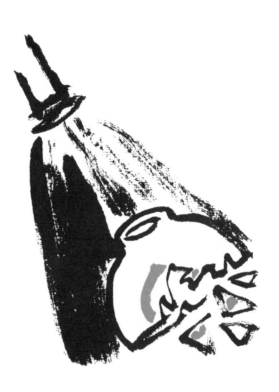

碎片會傷人
小心清除

CLEAR THE SHATTERED POT WITH CARE. SHARDS CUT DEEP.

PRUDENCE AVEC LES POTS CASSÉS, ILS POURRAIENT VOUS BLESSER.

養魚就不養貓

SOME COMBINATIONS MAKE FOR TROUBLE.

CERTAINES COMBINAISONS SONT SOURCE DE PROBLÈMES.

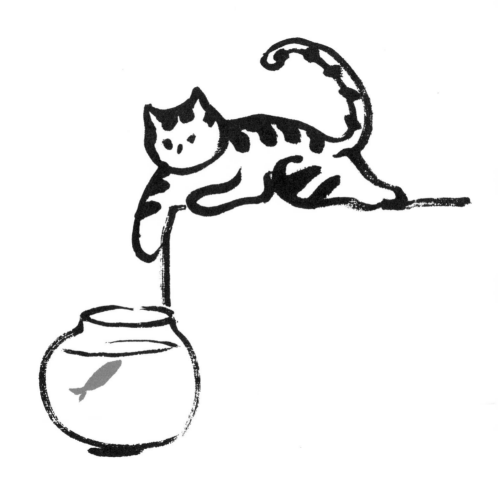

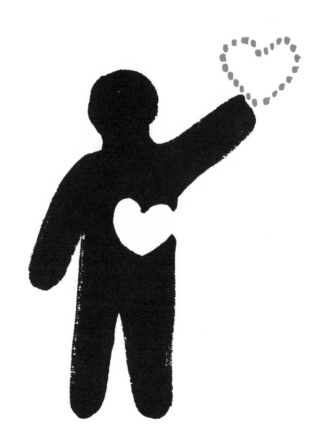

你無法給別人自己沒有的東西

YOU CANNOT GIVE WHAT YOU DO NOT HAVE.

ON NE PEUT DONNER CE QUE L'ON N'A PAS.

休息的機會多給自己腦筋

YOUR MIND NEEDS TO SWITCH OFF, TOO.

L'ESPRIT AUSSI A BESOIN DE REPOS.

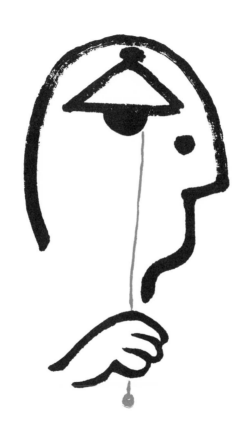

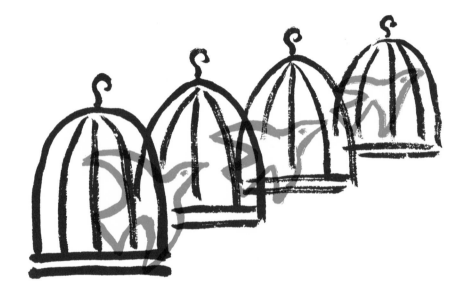

別從這個籠中又
飛到另一籠裡去

心種隨心開

YOUR THOUGHTS WILL GROW.

VOS PENSÉES S'ÉPANOUIRONT.

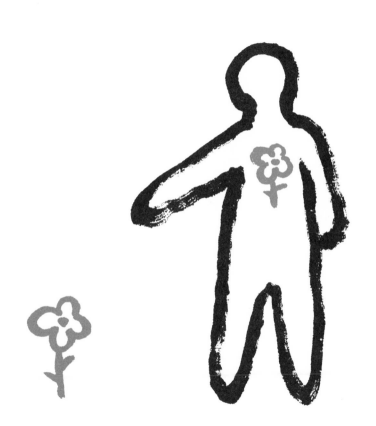

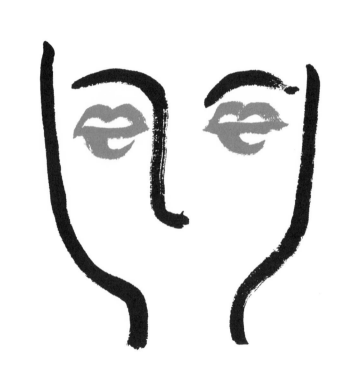

眼神比說話
更動人

EYES CAN BE MORE ELOQUENT THAN WORDS.

LE REGARD PEUT ÊTRE PLUS ÉLOQUENT QUE LA PAROLE.

悲劇的角色雖動人
最好留給別人去
演吧

LEAVE TRAGEDY FOR THE STAGE. YOU HAVE OTHER PRIORITIES IN LIFE.

LA TRAGÉDIE EST ÉMOUVANTE SUR SCÈNE, MAIS
ELLE N'EST PAS INDISPENSABLE DANS NOTRE VIE.

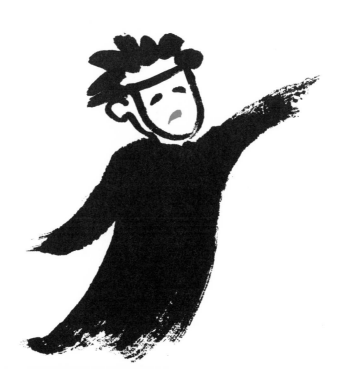

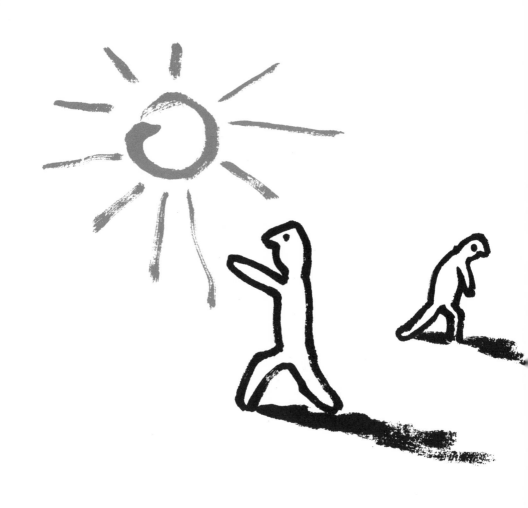

向着陽光走
讓影子追隨你

WALK TOWARD THE SUN AND LEAVE YOUR SHADOW BEHIND.

MARCHEZ FACE AU SOLEIL : VOTRE OMBRE RESTERA DERRIÈRE.

甜而蜜的桃子
存放不久

THE SWEETER THE FRUIT, THE SOONER IT ROTS.

PLUS SUCRÉ EST LE FRUIT, PLUS VITE IL SE GÂTE.

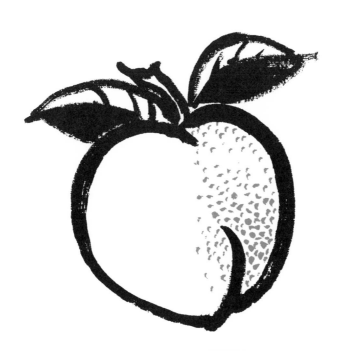

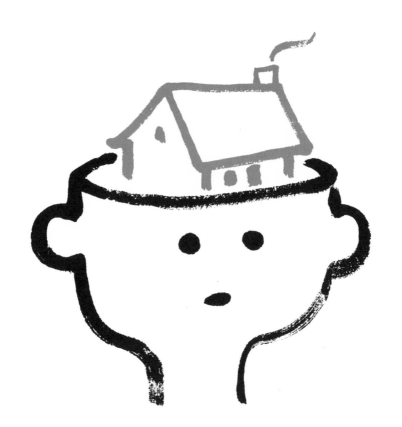

腦子不要只為一件
事裝滿了

NEVER GET PREOCCUPIED WITH JUST ONE THING.

RIEN NE MÉRITE D'OCCUPER ENTIÈREMENT NOTRE ESPRIT.

在人生的旅程中給自己幾個休息的平台

MAKE SURE THERE ARE LANDINGS IN THE STAIRWAY OF YOUR LIFE.

PRÉVOYEZ DES PALIERS DANS L'ESCALIER DE VOTRE VIE.

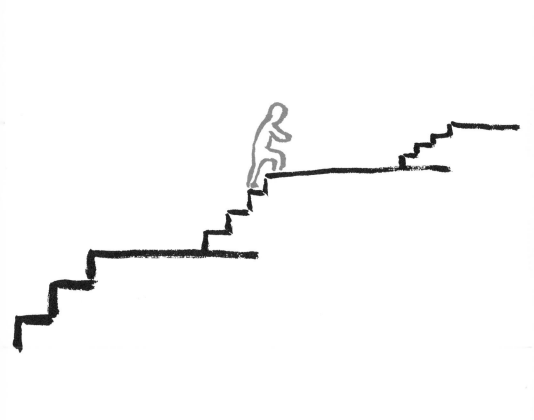

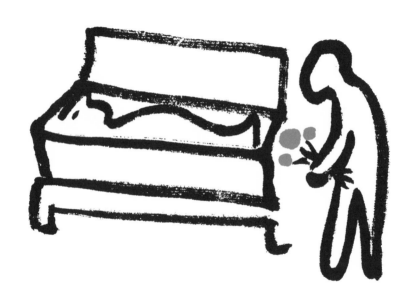

我們總會撥出時間參加朋友的葬禮

YES, ATTEND YOUR FRIENDS' FUNERALS. EVEN BETTER, VISIT THEM WHILE THEY ARE ALIVE.

C'EST BIEN DE PRENDRE LE TEMPS D'ASSISTER AUX FUNÉRAILLES D'UN AMI. C'EST ENCORE MIEUX DE LE VISITER DE SON VIVANT.

魚離開水時才
感覺水的重要

ONLY WHEN OUT OF THE WATER DOES THE FISH APPRECIATE ITS IMPORTANCE.

CE N'EST QU'UNE FOIS HORS DE L'EAU QUE LE POISSON EN SAISIT L'IMPORTANCE.

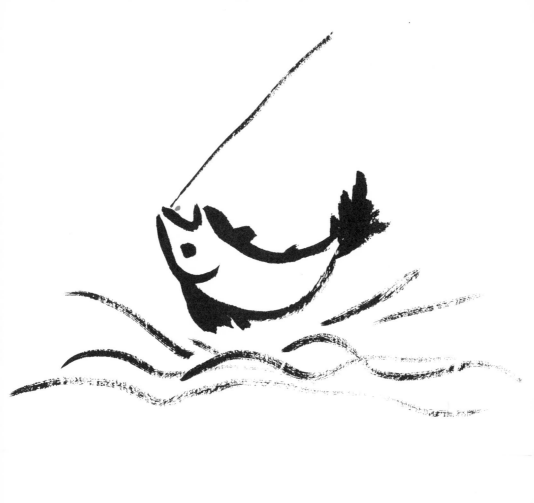

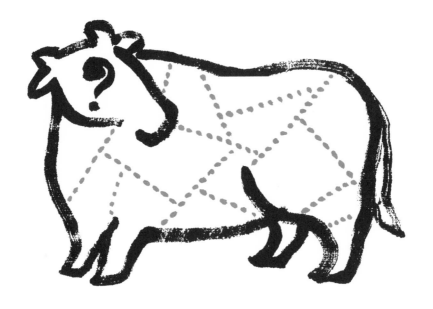

真不明白
為什麼我身體
有不同的價位

DO DIFFERENT PARTS OF MY BODY HAVE DIFFERENT VALUES?

LES PARTIES DE MON CORPS N'ONT-ELLES PAS TOUTES LA MÊME VALEUR ?

ASK THE SIGHTLESS TO BE YOUR EYES IN THE DARK.

DANS L'OBSCURITÉ, L'AVEUGLE DEVIENT NOTRE GUIDE.

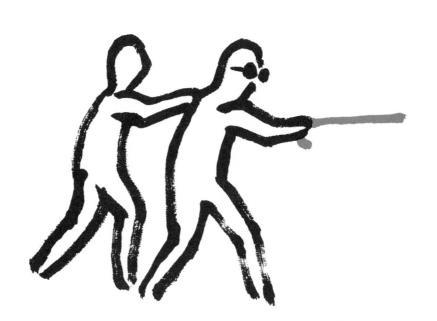

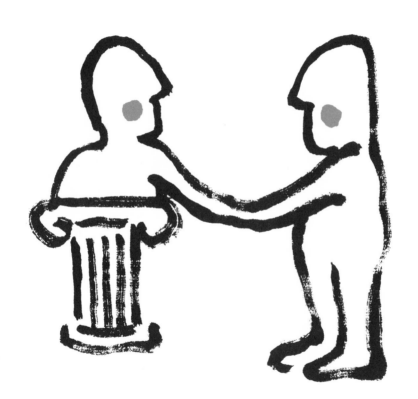

和自己的過去和解

MAKE PEACE WITH YOUR PAST.

RÉCONCILIEZ-VOUS AVEC VOTRE PASSÉ.

想念是沒有
距離的

IDEAS HAVE NO BORDERS.

LES PENSÉES N'ONT PAS DE FRONTIÈRES.

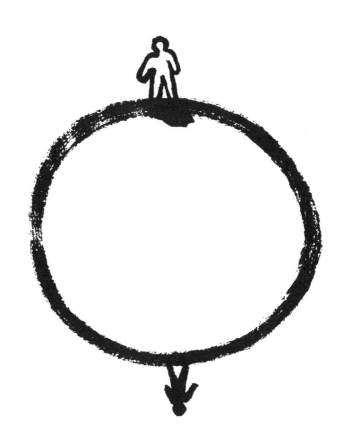

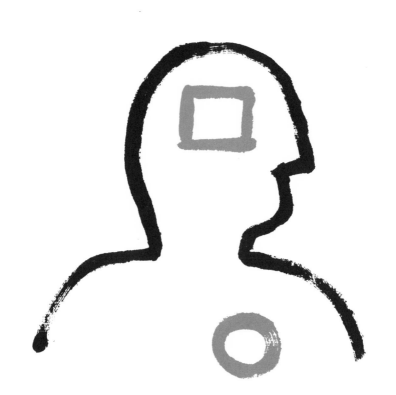

HEART AND MIND ARE EACH OTHER'S BEST FRIEND.

LE CŒUR ET LA RAISON S'AIDENT ET SE SOIGNENT MUTUELLEMENT.

追求「花未全開
月未圓」的境界

THE FLOWER IS NOT YET OPEN, THE MOON NOT FULLY ROUND,
THE REVELATION ONLY PARTIAL, BUT THE BEAUTY IS COMPLETE.

LA FLEUR N'EST PAS TOUT À FAIT OUVERTE, LA LUNE, PAS TOUT À FAIT
RONDE. LA RÉVÉLATION EST PARTIELLE, MAIS LA BEAUTÉ DEMEURE.

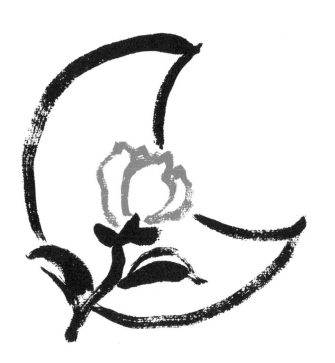

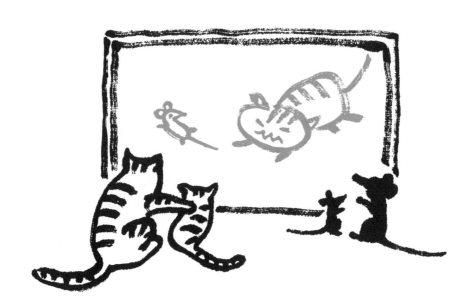

教育的目標
因人而異

LET INSTRUCTION SUIT THE LEARNER.

À CHAQUE ÉLÈVE SON ENSEIGNEMENT.

微笑往々能
化繁為簡

SMILES CROSS MILES.

LE SOURIRE FACILITE LES RAPPORTS HUMAINS.

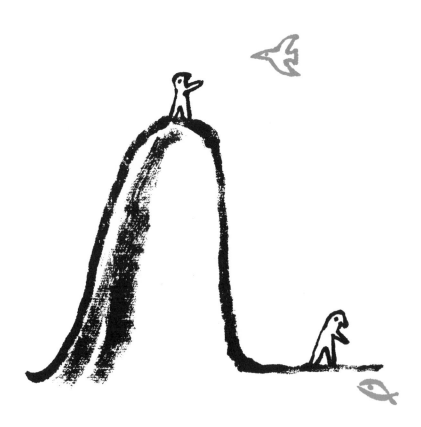

觀站
點的
也位
不置
一不
樣同

PERCEPTION DEPENDS ON POINT OF VIEW.

LA PERSPECTIVE CHANGE SELON NOTRE ANGLE DE VISION.

便宜一杯咖啡比律師

A CUP OF COFFEE IS CHEAPER THAN A LAWYER.

UN CAFÉ COÛTE MOINS CHER QU'UN AVOCAT.

攝影的祕訣是掌握按快門的時刻
人生也不過如此

IN LIFE AND PHOTOGRAPHY, SEIZE THE MOMENT.

DANS LA VIE COMME EN PHOTOGRAPHIE, IL FAUT SAVOIR SAISIR L'INSTANT.

水對投向它的東西
都先以圓來反應
然後漸之的散開

WATER RIPPLES TO ANYTHING DROPPED INTO IT, THEN RETURNS TO CALM.

L'EAU RÉAGIT À L'INTRUSION EN FORMANT DES CERCLES, PUIS ELLE SE CALME.

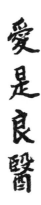

LOVE IS THE BEST PHYSICIAN.

L'AMOUR EST LE PLUS COMPÉTENT DES MÉDECINS.

面具戴多了
往往自己也不知道
自己是誰了

HABITUAL MASK WEARERS FORGET WHO THEY ARE.

À FORCE DE PORTER DES MASQUES, ON NE SAIT PLUS QUI L'ON EST VRAIMENT.

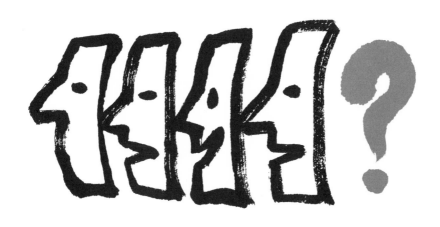

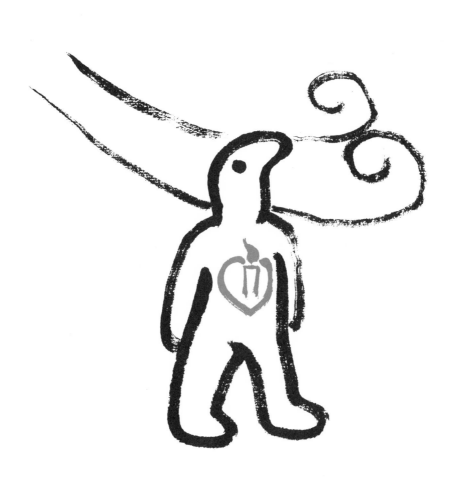

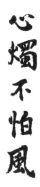

心燭不怕風

THE CANDLE IN YOUR HEART DOES NOT FEAR THE WIND.

LA FLAMME DU CŒUR NE CRAINT PAS LES BOURRASQUES.

我們多少，都像是畢加索的作品

THE CANVASES OF OUR LIVES CONCEDE NOTHING TO PICASSO.

LES TABLEAUX DE NOTRE VIE N'ONT RIEN À ENVIER À PICASSO.

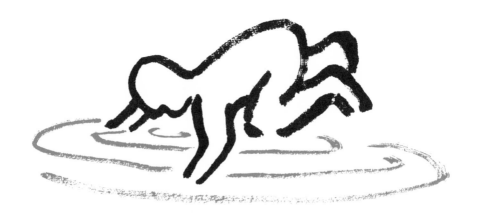

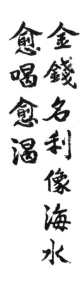

金錢名利像海水
愈喝愈渴

MONEY IS LIKE SEAWATER. THE MORE YOU DRINK, THE THIRSTIER YOU GET.

L'ARGENT EST COMME L'EAU SALÉE : PLUS ON S'Y ABREUVE, PLUS ON A SOIF.

再強烈的太陽也會下山

EVER THE MOST BRILLIANT SUN MUST SET.

MÊME LE SOLEIL LE PLUS ÉBLOUISSANT FINIT PAR SE COUCHER.

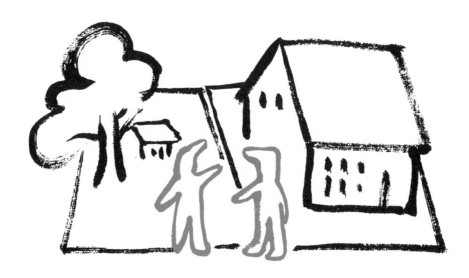

好美慕你的大房子
真喜歡你的大院子

"I WISH I HAD A BIG HOUSE." "I WISH I HAD YOUR BEAUTIFUL GARDEN."

« J'ENVIE VOTRE GRANDE MAISON. » « J'ENVIE VOTRE GRAND JARDIN. »

送你一把種子

IF YOU WATER THE EARTH WITHOUT PLANTING SEEDS, NOTHING WILL GROW.

ARROSER LA TERRE NE SUFFIT PAS : IL FAUT D'ABORD L'ENSEMENCER.

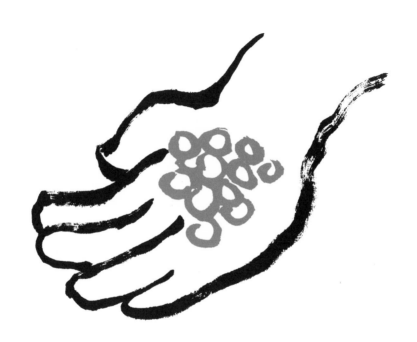

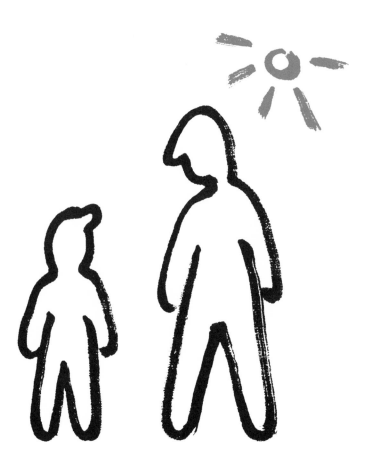

矮人也有長處
總是往上看

THE ADVANTAGE OF BEING SHORT IS ALWAYS LOOKING UPWARDS.

L'AVANTAGE DES PETITS EST DE DEVOIR TOUJOURS REGARDER VERS LE HAUT.

愛有時是盲目的

LOVE IS BLIND TO THE FUTURE.

LE REGARD AMOUREUX MANQUE DE CLAIRVOYANCE.

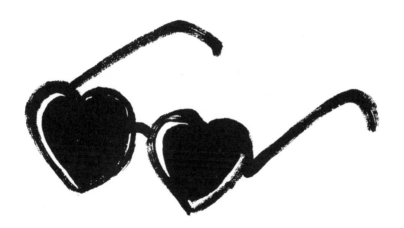

思維的模式
因人而異

NONE OF US THINKS ALIKE.

LES MODES DE PENSÉE SONT MULTIPLES.

真槍實彈的人生
是無法彩排的

LIFE IS A ONE-TIME PERFORMANCE. NO REHEARSALS.

LA VIE SE JOUE EN DIRECT, SANS RÉPÉTITIONS.

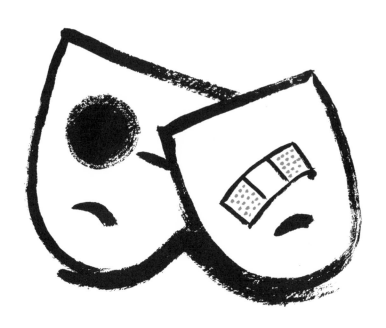

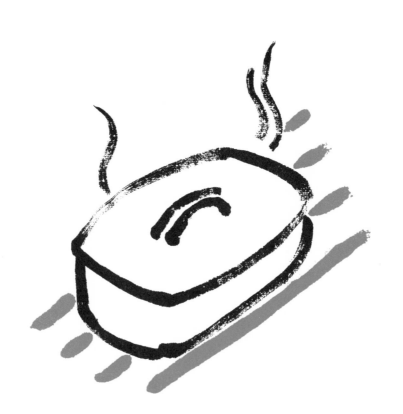

火候不到
別急着開鍋

DON'T LIFT THE LID BEFORE IT IS TIME.

LAISSEZ MIJOTER AUSSI LONGTEMPS QU'IL LE FAUDRA.

有時沉默更好

THINK BEFORE OPENING YOUR MOUTH.

OUVRIR LA BOUCHE PEUT PARFOIS ÊTRE PÉRILLEUX.

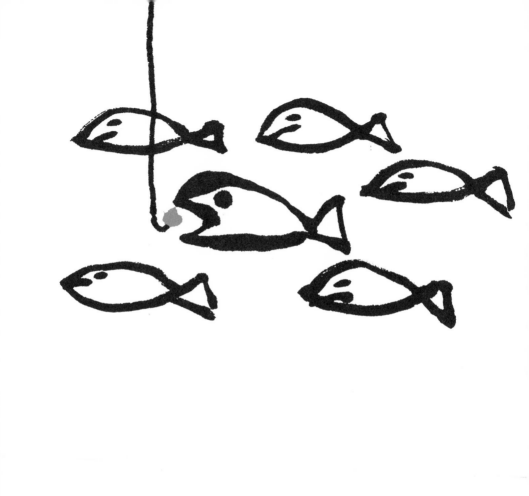

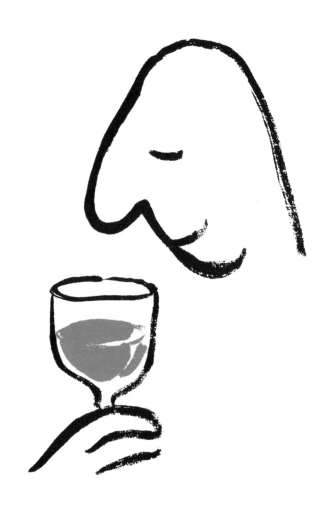

像好酒
人生別太早乾杯

SIP LIFE SLOWLY, LIKE A GOOD WINE.

SAVOUREZ LA VIE LENTEMENT, COMME UN BON VIN.

錢放在撲滿裡
是屬於小豬的

THE MONEY IN YOUR PIGGY BANK BELONGS TO THE PIGGY.

L'ARGENT QUE VOUS GARDEZ DANS VOTRE TIRELIRE APPARTIENT AU COCHON.

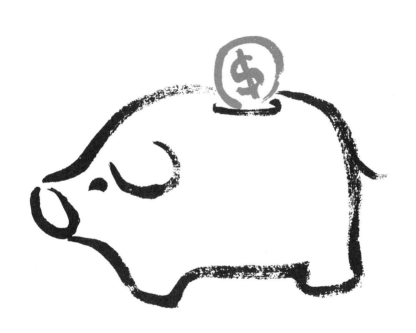

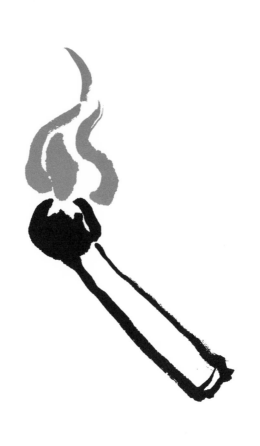

別小看一根火柴的作用

A CARELESS WORD IS LIKE A CARELESS MATCH.

PRÉVENONS LES DÉSASTRES : MESURONS NOS PAROLES.

每人都擁有一隻
控制別人的手

WE ALL LIKE TO PULL THE STRINGS.

NOUS SOMMES TOUS SENSIBLES À L'ATTRAIT DU POUVOIR.

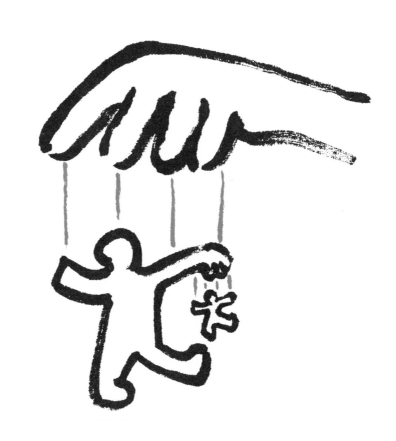

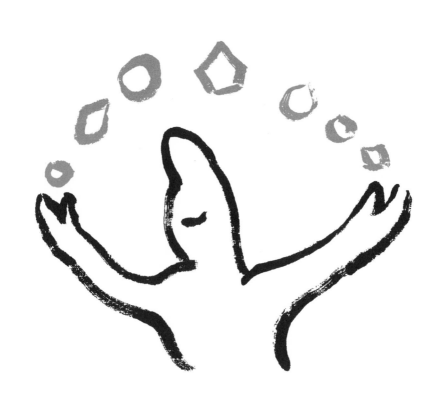

玩久了
總會失手

JUGGLE TOO LONG, AND YOU WILL MISS A CATCH.

À JONGLER TROP LONGTEMPS, ON FINIT PAR RATER SON COUP.

你習慣先選大的吃
還是先挑小的吃

WHEN YOU EAT, DO YOU START WITH THE BIGGEST OR THE SMALLEST?

MANGEZ-VOUS D'ABORD LES PLUS GROS OU LES PLUS PETITS ?

覺得自己是水
對方是魚
人與人之間就會
產生矛盾

BEWARE THE TRAP OF SEEING YOURSELF AS WATER, AND OTHERS AS FISH.

IL EST DIFFICILE DE VIVRE EN HARMONIE QUAND ON
SE PERÇOIT COMME L'EAU QUI ACCUEILLE LE POISSON.

每天要有時間
和自己相處

SPEND SOME TIME WITH YOURSELF EVERY DAY.

PRÉVOYEZ UNE RENCONTRE AVEC VOUS-MÊME CHAQUE JOUR.

沒有創意的反對
是沒有說服力的

OBJECTING FOR THE SAKE OF OBJECTING CONVINCES NO ONE.

S'OPPOSER SANS PROPOSER NE CONVAINC PERSONNE.

胡蘿蔔至少也
有鼓勵的作用

THE CARROT AT LEAST SERVES AS INCENTIVE.

LA CAROTTE A AU MOINS LE MÉRITE DE MOTIVER.

世界上對你最珍貴的是什麼

WHAT IS MOST PRECIOUS TO YOU?

QU'EST-CE QUI COMPTE LE PLUS AU MONDE POUR VOUS ?

帆要隨風調整
才能向目標前進

TO MAKE HEADWAY, TRIM YOUR SAILS TO THE WIND.

POUR AVANCER, AJUSTEZ VOTRE VOILE AU GRÉ DU VENT.

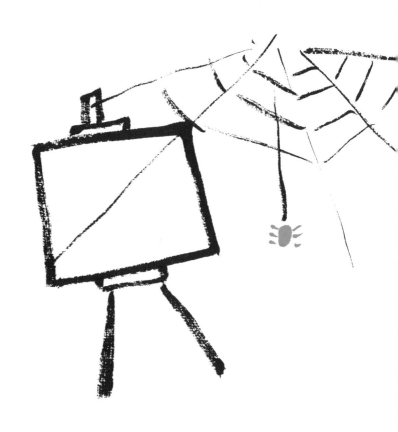

你的人生傑作

動筆了嗎

HAVE YOU BEGUN THE MASTERPIECE OF YOUR LIFE?

OÙ EN EST LE CHEF-D'ŒUVRE DE VOTRE VIE ?

人的一生不就是想
留下一點愛的痕跡

LOVE IS THE SUREST SIGN OF A LIFE WELL LIVED.

LA TRACE LA PLUS PROFONDE QU'ON PEUT LAISSER DE SA VIE EST CELLE DE L'AMOUR.

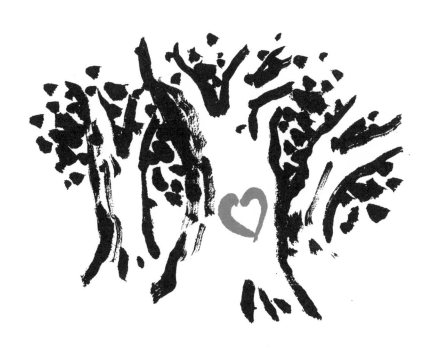